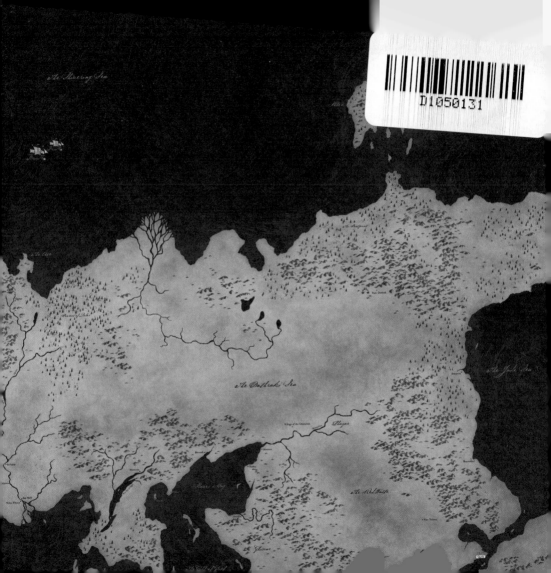

The Shivering Sea

The Dothraki Sea

The Jade Sea

Vaes Dothrak

The Forest of...

Village of the Unknown

The Red Waste

D1050131

GAME OF THRONES

IN MEMORIAM

GAME OF THRONES™

IN MEMORIAM

RUNNING PRESS

PHILADELPHIA · LONDON

Published by Running Press,
A Member of the Perseus Books Group

All rights reserved under the Pan-American and International Copyright Conventions

Printed in China

Books published by Running Press are available at special discounts for bulk purchases in the United States by
corporations, institutions, and other organizations. For more information, please contact the Special Markets
Department at the Perseus Books Group, 2300 Chestnut Street, Suite 200, Philadelphia, PA 19103, or call (800)
810-4145, ext. 5000, or e-mail special.markets@perseusbooks.com.

ISBN 978-0-7624-5702-1

Library of Congress Control Number: 2014951666

E-book ISBN 978-0-7624-5776-2

9 8 7 6 5 4 3 2 1
Digit on the right indicates the number of this printing

Game of Thrones series photographs by principal unit photographer, Helen Sloan

Additional photography by unit photographers Paul Schiraldi, Nick Briggs, Macall Polay,
Oliver Upton, and Keith Bernstein

VALAR MORGHULIS

The world of *Game of Thrones* is a dangerous place full of deceit, vengeance, mysterious forces, and war. In this book we remember many of those who have been lost to this treacherous landscape.

Valar Morghulis.

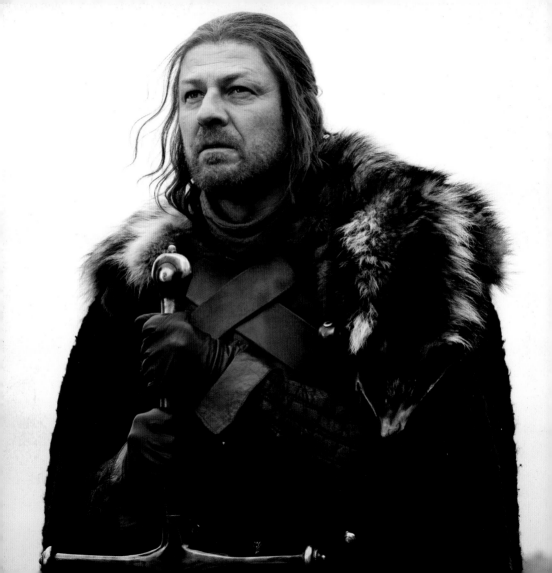

Eddard "Ned" Stark

House Stark

"Winter is coming."

Stoic, duty-bound, and honorable, Ned Stark embodied the values of the north. In moving to King's Landing to serve as Hand to his longtime friend, Robert Baratheon, Ned fell on the wrong side of court intrigues and paid for it with his life.

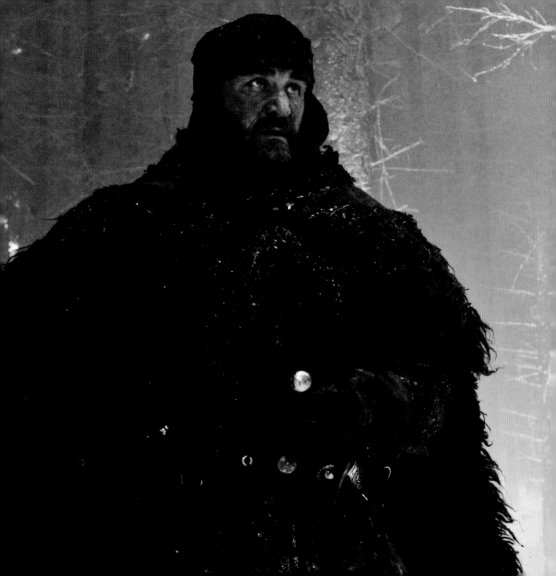

GARED

NIGHT'S WATCH

"OUR ORDERS WERE TO TRACK THE
WILDLINGS. WE TRACKED THEM.
THEY WON'T TROUBLE US NO MORE."

A ranger in the Night's Watch, Gared was beheaded
by a White Walker while beyond the Wall.

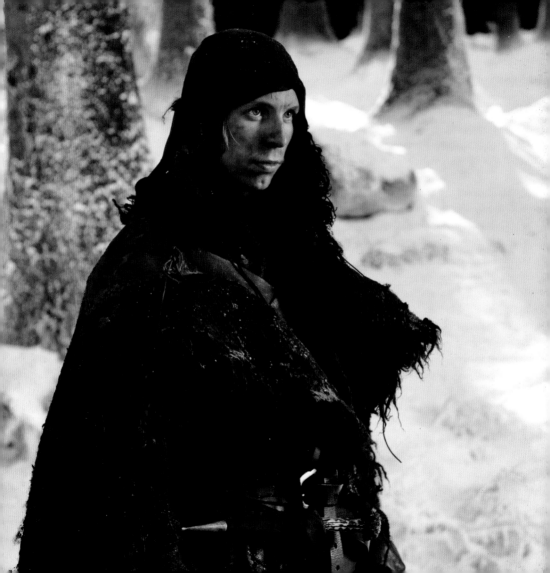

WILL

NIGHT'S WATCH

*"I SAW WHAT I SAW.
I SAW THE WHITE WALKERS."*

Will was a Night's Watch ranger who fled from a White Walker while on patrol north of the Wall. His reason for escape was not believed to be truthful and he was therefore executed as a deserter of the Night's Watch by Ned Stark.

LADY

HOUSE STARK

Lady was Sansa Stark's direwolf. After Arya Stark's direwolf, Nymeria, attacked Joffrey in an effort to protect her, Cersei Lannister ordered Ned to kill Lady as punishment for Nymeria's attack. Against his daughter's wishes, Ned carried out the task.

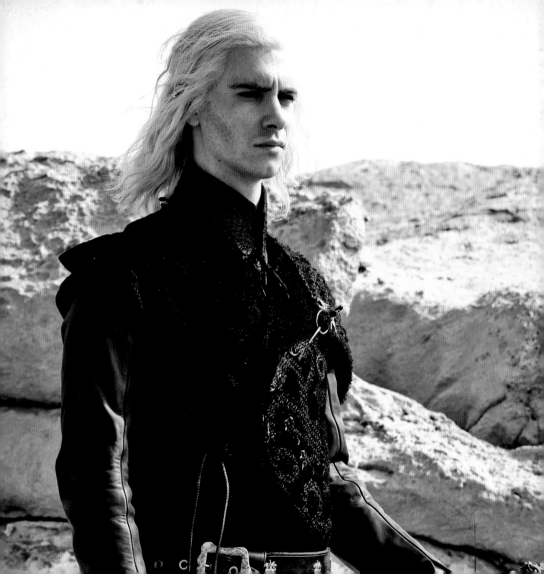

VISERYS TARGARYEN

HOUSE TARGARYEN

*"YOU DON'T WANT TO WAKE
THE DRAGON, DO YOU?"*

The only surviving male heir of House Targaryen, the young
Viserys was sent with his newborn sister, Daenerys, to Essos to
live in safety. In exile he grew obsessed with retaking his family's
throne, but Khal Drogo executed him with a crown of molten
gold before he could claim his post as king.

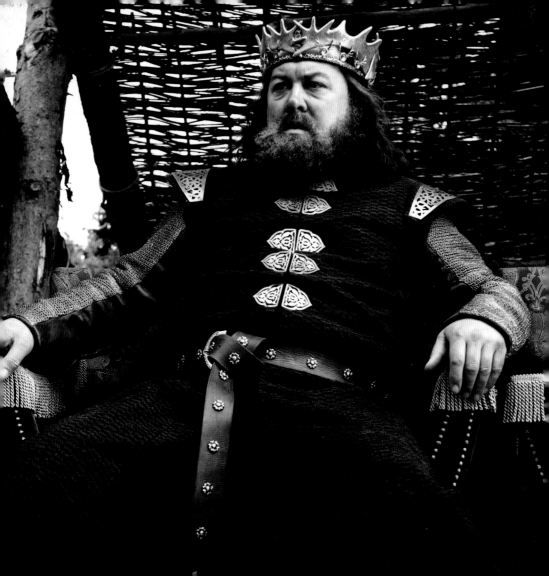

ROBERT BARATHEON

HOUSE BARATHEON

"YOU HELPED ME WIN THE IRON THRONE.
NOW HELP ME KEEP THE DAMN THING."

After Rhaegar Targaryen kidnapped his fiancée, Lyanna
Stark, Robert Baratheon led a rebellion against the Mad
King Aerys Targaryen. Aided by his childhood friend,
Lyanna's brother, Ned Stark, Robert was subsequently
crowned king. When he died suddenly in a hunting
accident, his heir, Joffrey, claimed the throne.

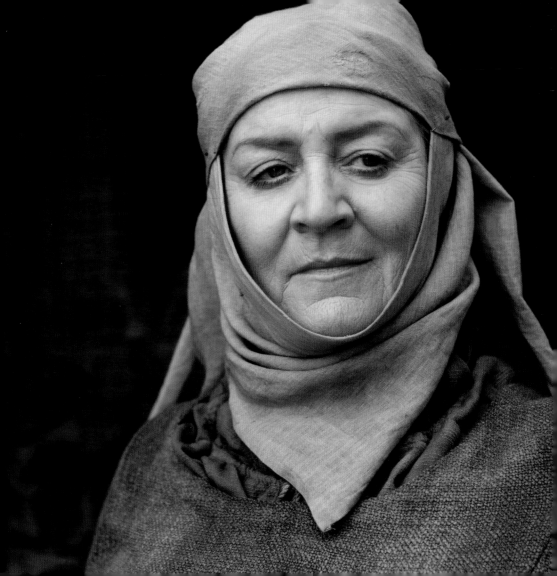

MORDANE

HOUSE STARK

"IT IS IMPORTANT TO REMEMBER WHERE YOU COME FROM."

Septa Mordane served as a tutor to the girls at Winterfell and traveled with them to King's Landing when Ned Stark was named Hand of the King. After Ned was accused of treason, Lannister soldiers killed Septa Mordane while she was trying to protect Sansa Stark.

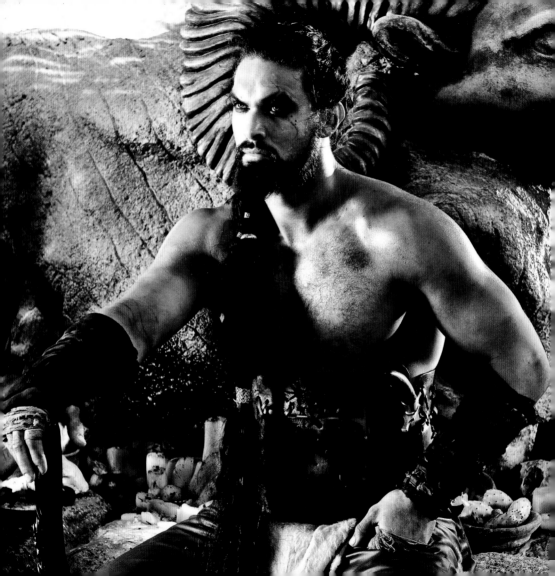

DROGO

"A KHAL DOES NOT NEED A CHAIR TO SIT UPON. HE ONLY NEEDS A HORSE."

A fierce khal warrior who led a tribe of horsemen in Essos, Drogo had never been defeated in battle until he succumbed to a wound that festered after the meddling of the Lhazareen priestess Mirri Maz Duur.

Mirri Maz Duur

"Only death pays for life."

A Lhazareen priestess, Mirri Maz Duur was rescued by Daenerys Targaryen after she watched her village burn at the hands of Drogo's khalasar. The priestess betrayed Daenerys by causing the pregnant queen to miscarry and reducing an injured Drogo to a catatonic state. Daenerys took her revenge by burning Mirri Maz Duur on the khal's funeral pyre.

BERIC DONDARRION

BROTHERHOOD WITHOUT BANNERS

"THAT'S WHAT WE ARE: GHOSTS.
YOU CAN'T SEE US BUT WE SEE YOU.
NO MATTER WHAT CLOAK YOU WEAR."

Lord of Blackhaven, Beric Dondarrion arrived in King's Landing to compete in the Tournament of the Hand, given in honor of Ned Stark, then Hand of the King. After Gregor Clegane terrorized the Riverlands, Lord Beric was tasked by Ned to bring him to justice. A follower of the Red faith, Beric has been brought back to life several times by Thoros of Myr.

CRESSEN

HOUSE BARATHEON

"SINCE THAT BOAR KILLED HIS BROTHER, EVERY LORD WANTS A CORONATION."

Maester to Stannis Baratheon, Cressen grew alarmed by Melisandre's increasing influence on Stannis and the king's rejection of the Faith of the Seven. When Cressen tried to poison the Red priestess, he succumbed instead.

Rakharo

House Targaryen

"I will not fail you,
blood of my blood."

Daenerys' Dothraki bodyguard, Rakharo was decended
from a line of bloodriders. Among those who stayed with
Daenerys after Drogo's death, and the first to declare
her "blood of my blood," Rakharo was killed by a rival
khalasar during a scouting mission.

YOREN

· Night's Watch ·

"You asked without manners
and I chose not to answer."

The Night's Watch recruiter who traveled the kingdom in
search of new brothers to bring back to the Wall, Yoren
spirited Arya Stark away from King's Landing after her
father's execution. He died at the hands of Lannister men
during his journey to return Arya to Winterfell.

Lommy

"Two men fighting isn't a battle."

A Night's Watch recruit from King's Landing who was traveling north with Arya Stark, Lommy was injured and then killed by the Lannister soldier Polliver when their caravan was stopped. Arya told the king's men that the dead boy was Gendry, aware the soldiers were looking for him.

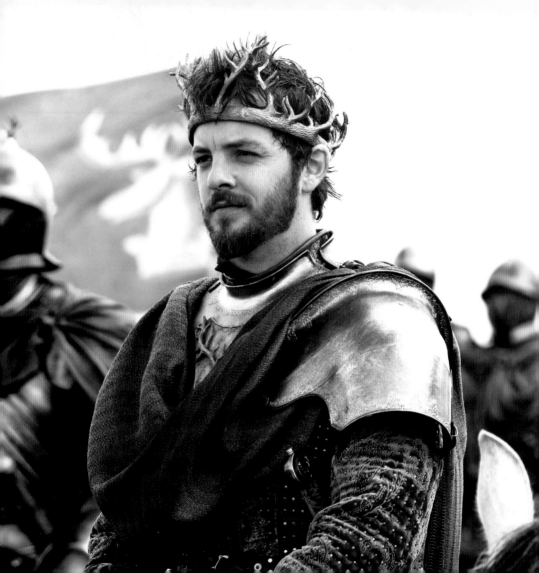

RENLY BARATHEON

HOUSE BARATHEON

"AH, YOU MUST BE THIS FIRE PRIESTESS
WE HEAR SO MUCH ABOUT. MM, BROTHER . . .
NOW I UNDERSTAND WHY YOU FOUND
RELIGION IN YOUR OLD AGE."

The youngest of the three Baratheon brothers, Renly's keen fashion sense and friendly style contributed to his popularity at court. Renly fervently believed he would be a better king than his brother Stannis or his nephew Joffrey, but he didn't live to prove it.

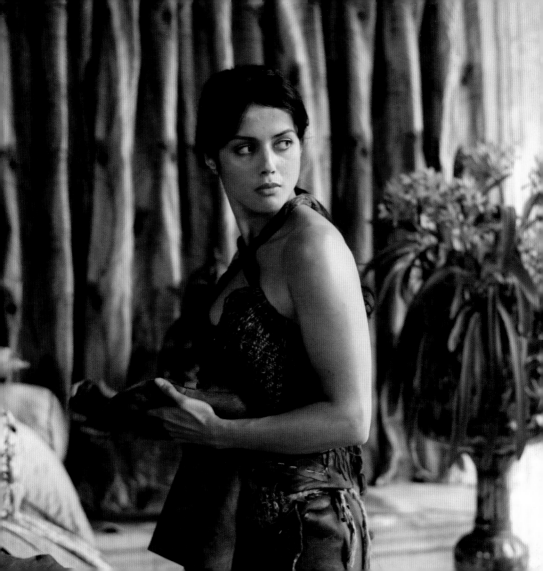

Irri

House Targaryen

"It is known."

A handmaiden who tutored Daenerys in Dothraki language and customs, Irri remained with her khaleesi after Drogo's death. She was murdered when Daenerys' dragons were stolen.

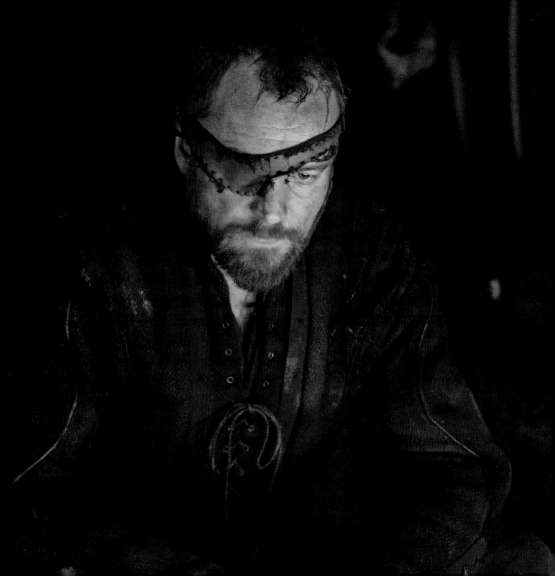

Beric Dondarrion

Brotherhood Without Banners

"That's what we are: Ghosts. You can't see us but we see you. No matter what cloak you wear."

Lord of Blackhaven, Beric Dondarrion arrived in King's Landing to compete in the Tournament of the Hand, given in honor of Ned Stark, then Hand of the King. After Gregor Clegane terrorized the Riverlands, Lord Beric was tasked by Ned to bring him to justice. A follower of the Red faith, Beric has been brought back to life several times by Thoros of Myr.

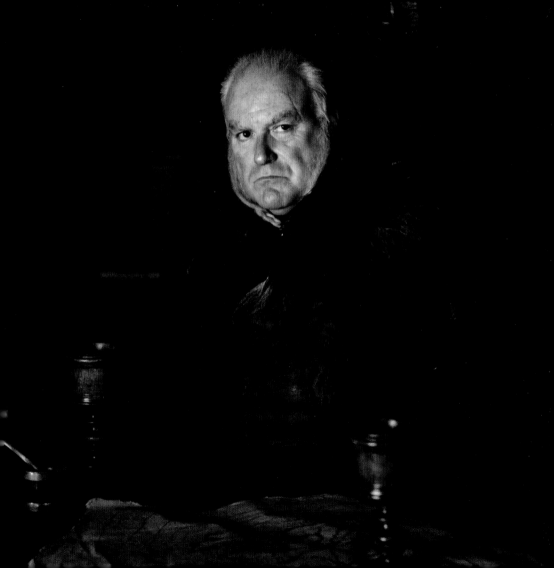

RODRIK CASSEL

HOUSE STARK

"I SHOULD HAVE PUT A SWORD IN YOUR
BELLY INSTEAD OF IN YOUR HAND."

Winterfell's Master at Arms, Ser Rodrik served as
the Starks' primary military and security advisor.
He was sloppily beheaded by Theon Greyjoy.

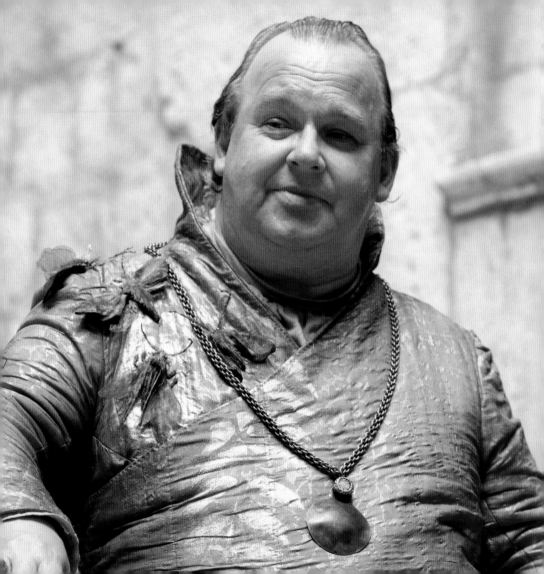

Spice King

*"Forgive me, little princess,
but I cannot make an investment
based on wishes and dreams."*

A member of the Thirteen of Qarth, the Spice King never
told Daenerys his real name. He was killed, along with
other members of the Thirteen, by Pyatt Pree.

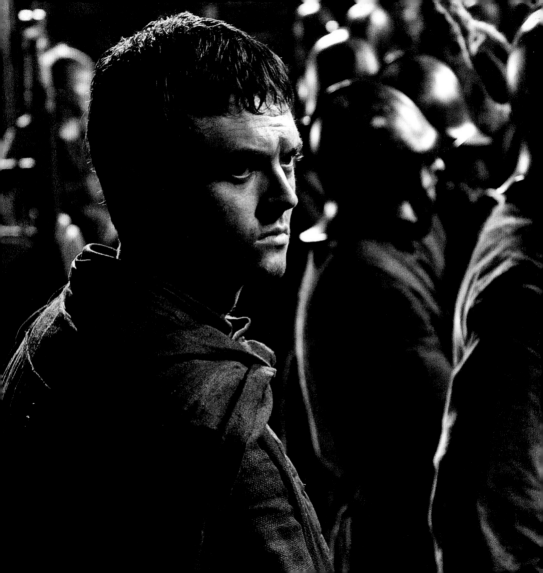

MATTHOS SEAWORTH

HOUSE BARATHEON

"THIS IS NOT MADNESS.
THIS IS THE WAY."

Unlike his father Davos Seaworth, Matthos
was a true believer of the Lord of the Light.
He died at the Battle of the Blackwater.

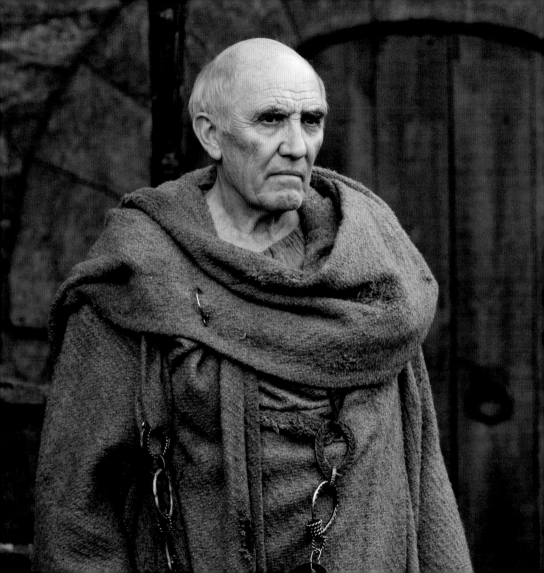

LUWIN

HOUSE STARK

"MAYBE MAGIC ONCE WAS A MIGHTY FORCE
IN THE WORLD BUT NOT ANYMORE."

Maester of Winterfell, Luwin provided wise counsel
to the Starks. He was murdered by Greyjoy men after
Theon captured the castle.

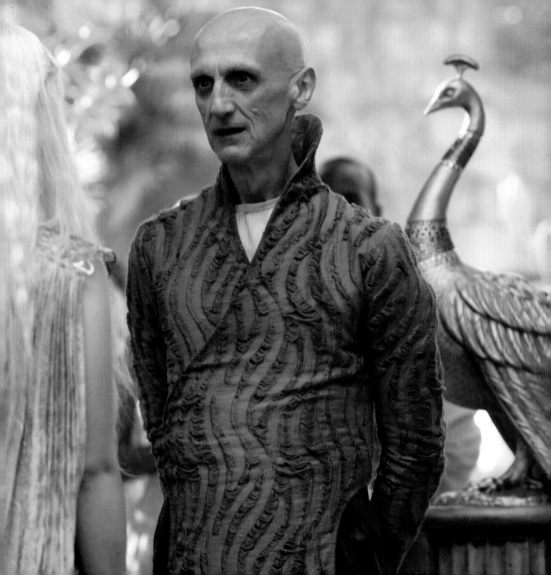

Pyat Pree

"The mother of dragons must be with her babies. She will give them her love and they will thrive by her side . . . forever."

A warlock of Qarth, Pyat Pree is a member of the Thirteen who met Daenerys outside of the walls of the city. He colluded with Xaro Xhoan Daxos to imprison Daenerys and steal her dragons, but he was killed when Daenerys commanded the dragons to burn him.

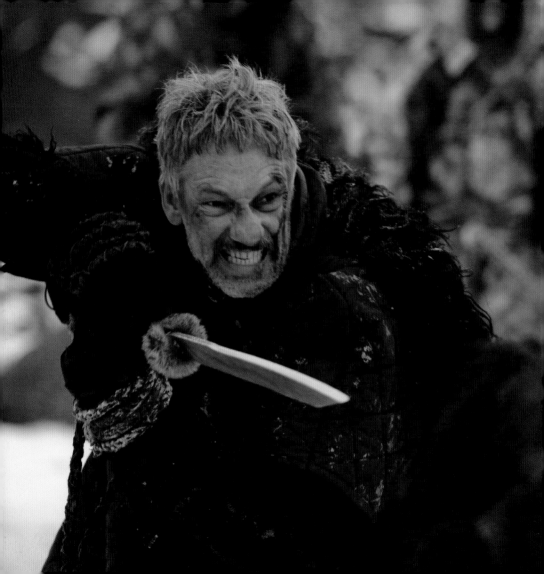

Qhorin Halfhand

Night's Watch

"We are the watchers on the wall."

A ranger in the Night's Watch, Qhorin earned his nickname after losing most of his right hand in a fight with a wildling. Based in the Shadow Tower, he encountered the Lord Commander's scouting party at the Fist of the First Men and took Jon Snow under his wing. At Qhorin's urging, Jon Snow killed him to infiltrate the wildlings.

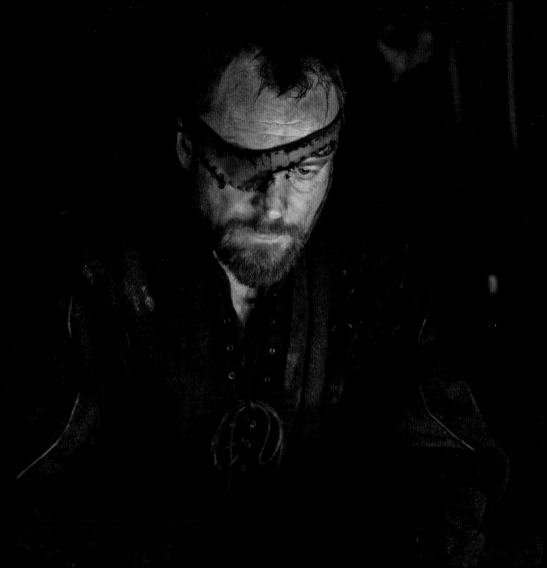

Beric Dondarrion

Brotherhood Without Banners

"That's what we are: Ghosts.
You can't see us but we see you.
No matter what cloak you wear."

Lord of Blackhaven, Beric Dondarrion arrived in King's Landing
to compete in the Tournament of the Hand, given in honor
of Ned Stark, then Hand of the King. After Gregor Clegane
terrorized the Riverlands, Lord Beric was tasked by Ned to bring
him to justice. A follower of the Red faith, Beric has been brought
back to life several times by Thoros of Myr.

Doreah

"Once there were two moons in the sky but one wandered too close to the sun and it cracked in the heat. Out of it poured a thousand dragons and they drank the sun's fire."

A former concubine who worked in the pleasure houses of Lys, Doreah was a gift from Viserys to Daenerys. Eager to advance her own position, Doreah allied herself with Qartheen noble Xaro Xhoan Daxos and helped steal Dany's dragons. Dany locked them both in an empty vault when she discovered their betrayal.

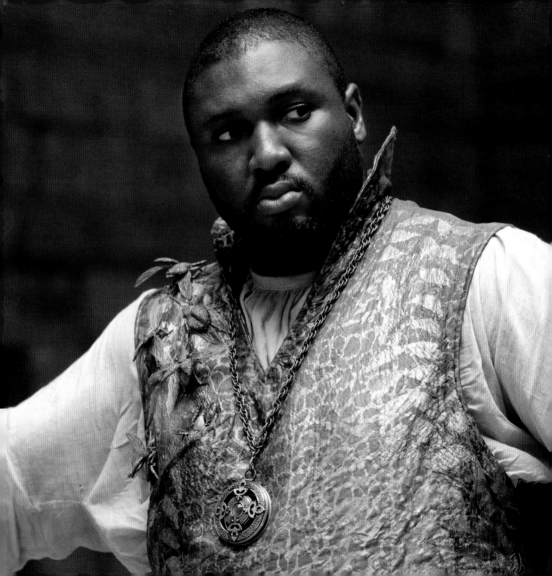

Xaro Xhoan Daxos

"After all, here I am, a savage from the summer isles and Qarth still stands."

A wealthy spice merchant from Qarth, Xaro Xhoan Daxos was the one member of the Thirteen who spoke up for Daenerys when she arrived in Qarth. He conspired with Pyat Pree to take the city and Daenerys' dragons, and was locked in his vault with Doreah when Daenerys discovered his treachery.

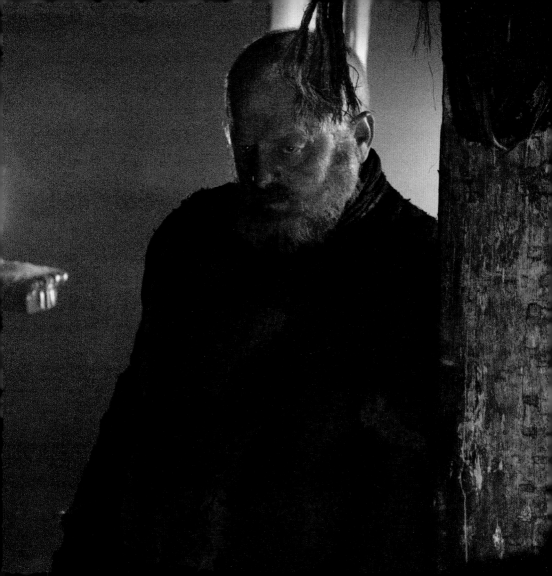

CRASTER

"WHEN YOU'RE ALL THE WAY NORTH
THERE'S ONLY ONE DIRECTION TO GO."

As the wildling who lived nearest to Castle Black, Craster hosted
the men of the Night's Watch in exchange for wine and tools. An
ungenerous host who made his daughters his wives, Craster was
only tolerated by Lord Commander Mormont out of necessity. He
and the Lord Commander died in an uprising led by the mutinous
band of Night's Watch brothers.

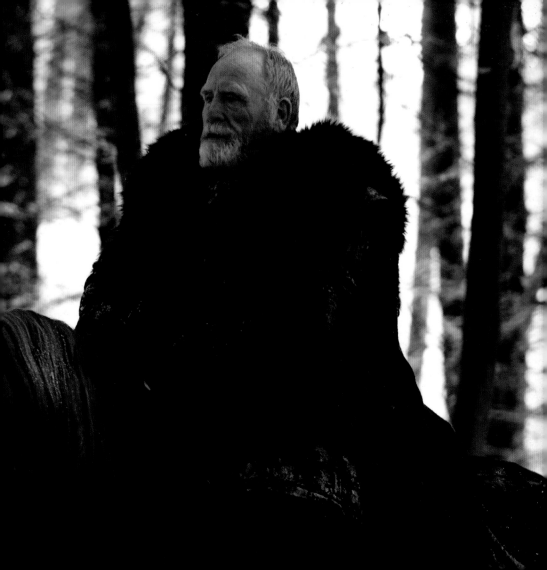

Jeor Mormont

Night's Watch

"When dead men and worse come hunting for us in the night, do you think it matters who sits on the iron throne?"

A grave and formidable fighter who gave up his claim on his ancestral home of Bear Island to assume command of the Night's Watch, Lord Commander Mormont was known to his troops as "Old Bear." The father of the disgraced knight Jorah Mormont, he took Jon Snow under his wing. The Lord Commander was killed by one of his own men during a mutiny at Craster's Keep.

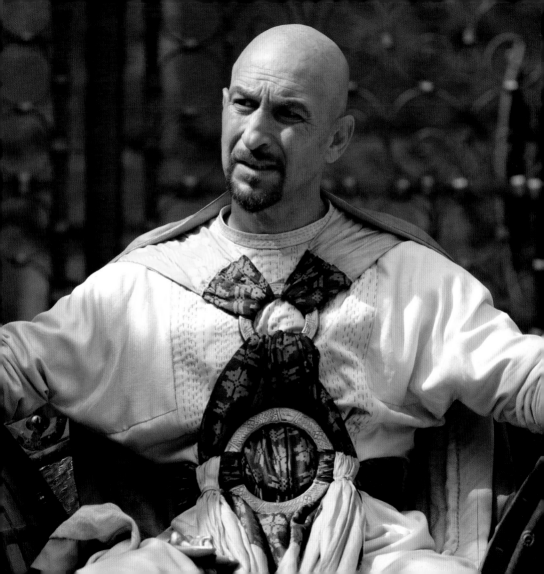

Kraznys

"You speak Valaryan?"

A master slaver in Astapor, Kraznys trained and traded the city's famous Unsullied soldiers. He agreed to sell his entire army to Daenerys in exchange for a dragon, but Drogon killed him at Deanerys' command.

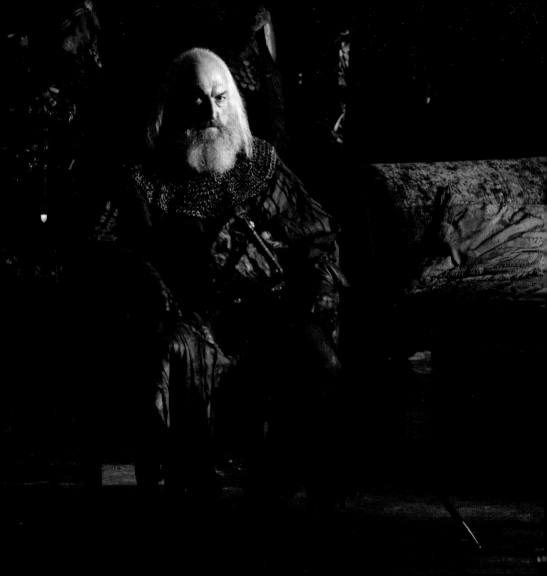

RICKARD KARSTARK

HOUSE KARSTARK

"IN WAR YOU KILL YOUR ENEMIES."

As head of House Karstark, an ancient family of the North that can trace its bloodline back to House Stark and the First Men, Lord Karstark readily answered Robb Stark's call when he raised his banners. His son died at the hands of Jaime Lannister, but Karstark's grief turned to fury when Catelyn Stark set the Kingslayer free. He was beheaded by King Robb when he killed two young Lannister hostages, and openly insulted Robb for marrying Talisa.

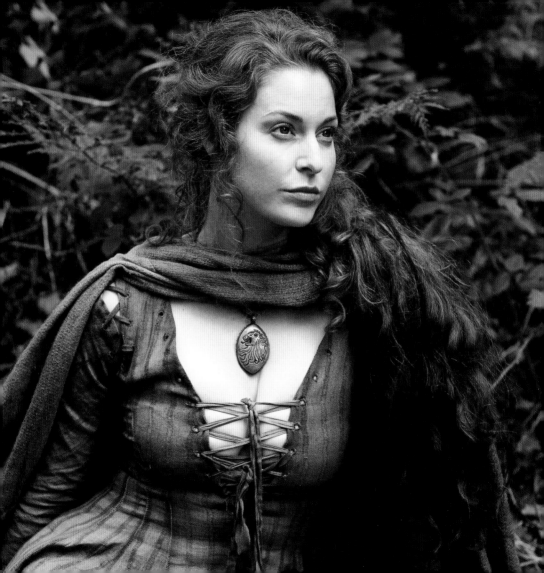

Ros

"It's not easy for girls like us."

A prostitute from the North who journeyed to
King's Landing, Ros helped Littlefinger run his brothel.
When Littlefinger discovered she was a spy for Varys,
he offered her to Joffrey to satisfy the king's bloodlust.
Joffrey killed her with his crossbow.

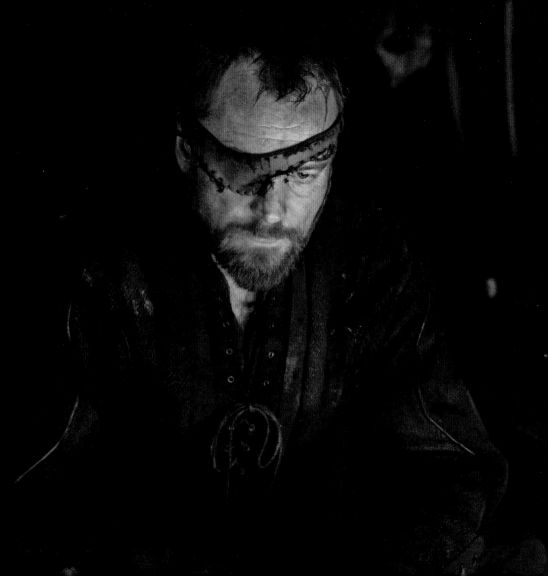

Beric Dondarrion

Brotherhood Without Banners

"That's what we are: Ghosts.
You can't see us but we see you.
No matter what cloak you wear."

Lord of Blackhaven, Beric Dondarrion arrived in King's Landing to compete in the Tournament of the Hand, given in honor of Ned Stark, then Hand of the King. After Gregor Clegane terrorized the Riverlands, Lord Beric was tasked by Ned to bring him to justice. A follower of the Red faith, Beric has been brought back to life several times by Thoros of Myr.

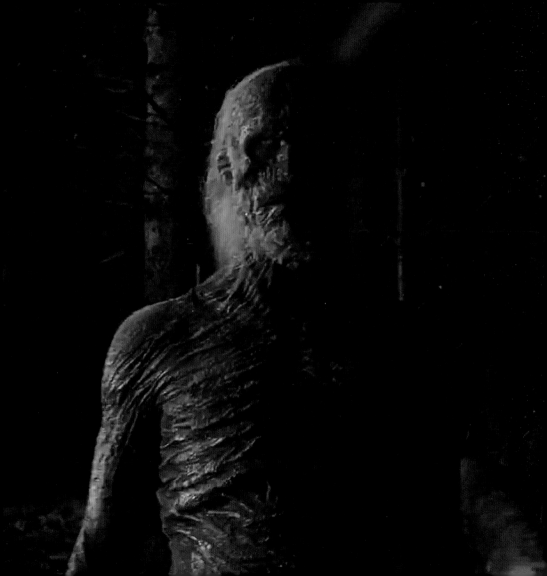

WHITE WALKER

While making their way to the safety of Castle Black, Samwell Tarly and Gilly encountered a White Walker, who had come to take Gilly's baby. Working on instinct, Sam killed this particular White Walker by stabbing it in the back with a dragonglass blade.

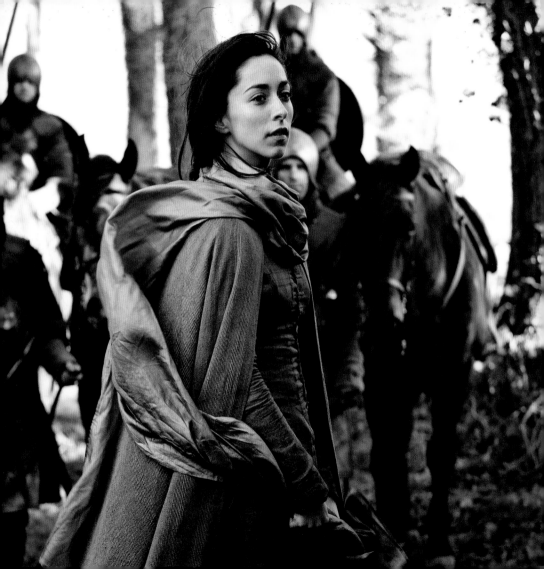

TALISA STARK

HOUSE STARK

"I DECIDED I WOULD NOT WASTE MY
YEARS PLANNING DANCES AND MASQUERADES
WITH THE OTHER NOBLE LADIES."

Although a highborn lady of Volantis, Talisa trained in the
medical arts. After a short and passionate courtship, she
and Robb Stark were married, breaking a promise Robb
had made to Walder Frey. Talisa, Robb, and Catelyn Stark
were subsequently murdered by a vengeful Lord Walder,
who was acting in service of Tywin Lannister.

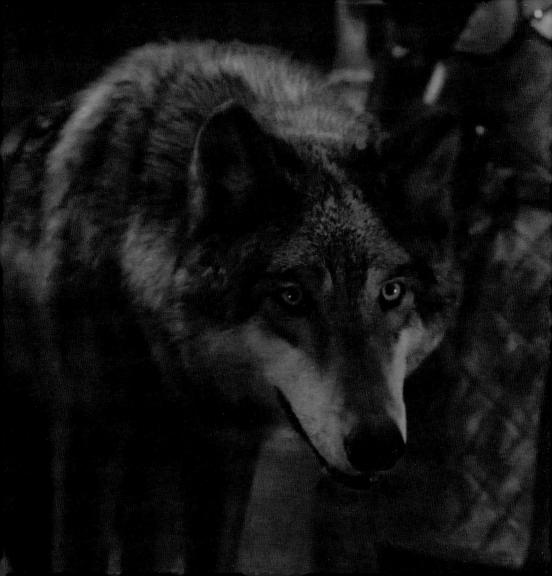

GREY WIND

HOUSE STARK

Grey Wind was Robb Stark's direwolf.
He was killed during the massacre
known as the Red Wedding.

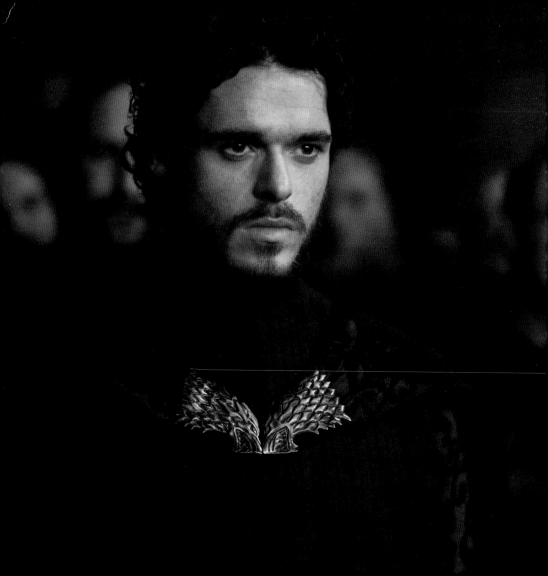

ROBB STARK

HOUSE STARK

"WE'LL ALL BE TOGETHER SOON. I PROMISE."

As Lord of Winterfell and then King in the North, Robb always upheld the responsibilities that came with his titles. Robb's one lapse was marrying Talisa Maegyr when he was already engaged to marry a Frey. In retaliation, Lord Walder Frey orchestrated the murders of Robb, Talisa, and Catelyn while playing host to the Starks at his daughter's wedding.

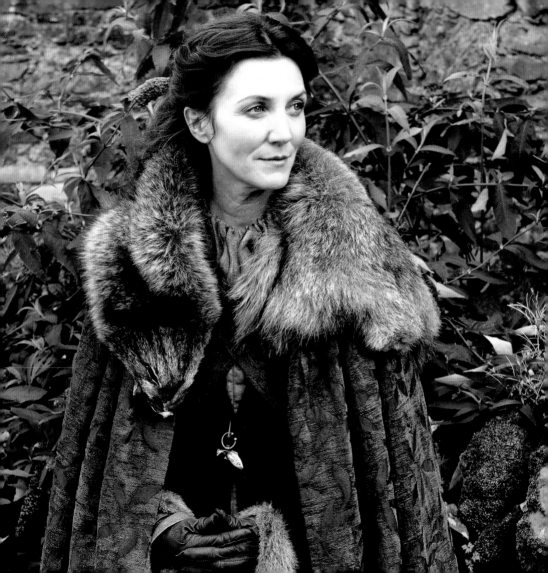

CATELYN STARK

HOUSE STARK

"ALL THIS HORROR THAT'S COME TO
MY FAMILY IS ALL BECAUSE I COULDN'T
LOVE A MOTHERLESS CHILD."

Catelyn married Ned Stark after King Aerys executed Ned's
brother, Brandon, to whom Catelyn was bethrothed. Though she
and Ned barely knew each other at the time of their wedding,
their love grew strong over the years. After Ned's death, Catelyn
tried to reunite her scattered family, but she was murdered,
along with her son Robb and daughter-in-law Talisa, at the Twins.

Polliver

House Lannister

"These are the king's colors. No one's standing in his way now, which means no one's standing in ours."

Polliver was one of the Lannister soldiers who stopped Arya Stark and the Night's Watch recruits on their way to Castle Black. When Polliver murdered a recruit called Lommy with Arya's sword, he earned himself a place on Arya's death list. Arya and the Hound encountered Polliver in the Riverlands, where she killed him the same way he killed Lommy.

Joffrey Baratheon

House Baratheon

"Everyone is mine to torment."

Over-indulged and cowardly, King Joffrey exhibited a cruel streak toward the vulnerable—a trait for which his uncle Tyrion had little patience. Joffrey was murdered with poisoned wine during his and Margaery Tyrell's wedding celebration.

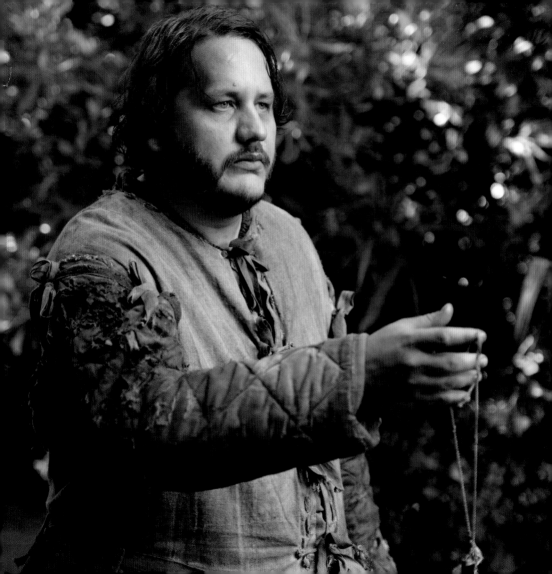

DONTOS HOLLARD

HOUSE HOLLARD

"TAKE IT. WEAR IT. LET MY NAME HAVE ONE MORE MOMENT IN THE SUN BEFORE IT DISAPPEARS FROM THE WORLD."

Ser Dontos was the last surviving member of House Hollard, a family obliterated by Aerys II. Sansa Stark saved him from death after he offended King Joffrey during his nameday celebration. In gratitude, he helped Sansa escape after Joffrey's murder, only to be killed himself by Littlefinger.

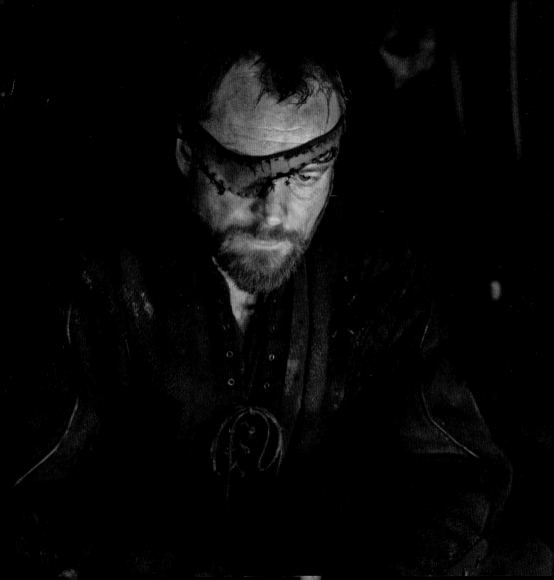

BERIC DONDARRION

BROTHERHOOD WITHOUT BANNERS

"THAT'S WHAT WE ARE: GHOSTS.
YOU CAN'T SEE US BUT WE SEE YOU.
NO MATTER WHAT CLOAK YOU WEAR."

Lord of Blackhaven, Beric Dondarrion arrived in King's Landing
to compete in the Tournament of the Hand, given in honor
of Ned Stark, then Hand of the King. After Gregor Clegane
terrorized the Riverlands, Lord Beric was tasked by Ned to bring
him to justice. A follower of the Red faith, Beric has been brought
back to life several times by Thoros of Myr.

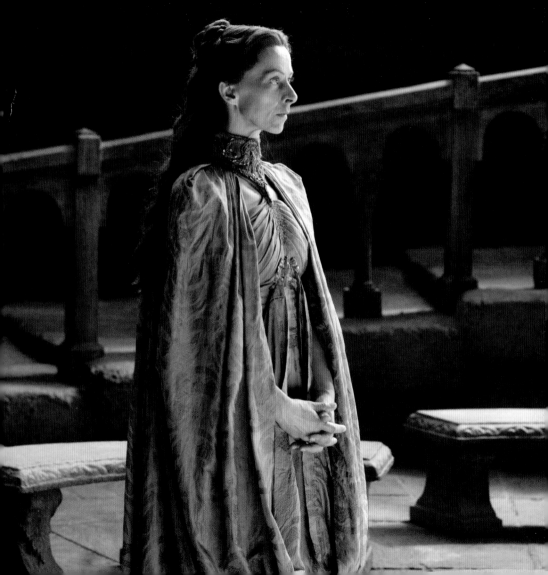

LYSA BAELISH

HOUSE ARRYN

"THAT'S WHAT HAPPENS TO PEOPLE WHO STAND BETWEEN PETER AND ME. LOOK DOWN! LOOK DOWN! LOOK DOWN!"

Catelyn Stark's younger sister, Lysa, was married off to the much older Jon Arryn, the former Hand of the King, when Robert Baratheon led his rebellion against the Mad King Aerys. After her husband's unexpected death, Lysa fled to the Eyrie, where she kept a careful eye on her son Robin and avoided the war below. She eagerly married her childhood love, Petyr "Littlefinger" Baelish—who courted her to secure the region for the kingdom—but he killed her by pushing her out of the Moon Door when she threatened her niece, Sansa.

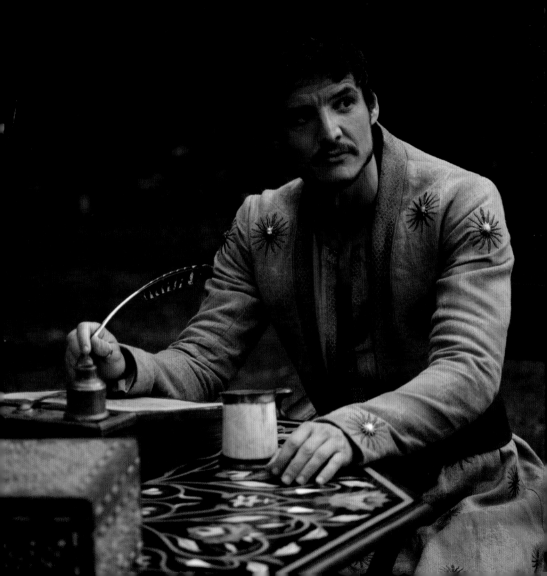

OBERYN MARTELL

HOUSE MARTELL

"TELL YOUR FATHER I'M HERE.
AND TELL HIM THE LANNISTERS AREN'T
THE ONLY ONES WHO PAY THEIR DEBTS."

A prince of Dorne, Oberyn Martell was also a fierce fighter who earned the nickname "The Red Viper." He spent time in the Citadel but quit his studies before earning a full set of links. Prince Oberyn was killed by Gregor "The Mountain" Clegane while serving as Tyrion Lannister's champion during his trial by combat for the murder of King Joffrey.

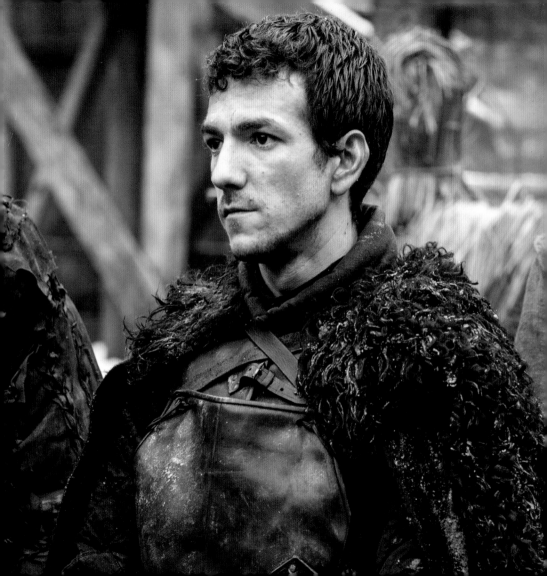

Pyp

Night's Watch

"I've never thrown a spear before,
I've never held a sword with a proper
edge. This is no place for me to be."

A recruit who joined the Watch after he was accused of
stealing, Pyp later revealed to his brothers that it was not
theft, but the rejection of a highborn lord's advances, that
sentenced him to a post on the Wall. Pyp remained at Castle
Black while the rangers ventured beyond the Wall. He was
slain by Ygritte's arrow during the Battle of Castle Black.

Mag the Mighty

A giant in service to Mance Rayder, Mag was
killed during the Battle of Castle Black.

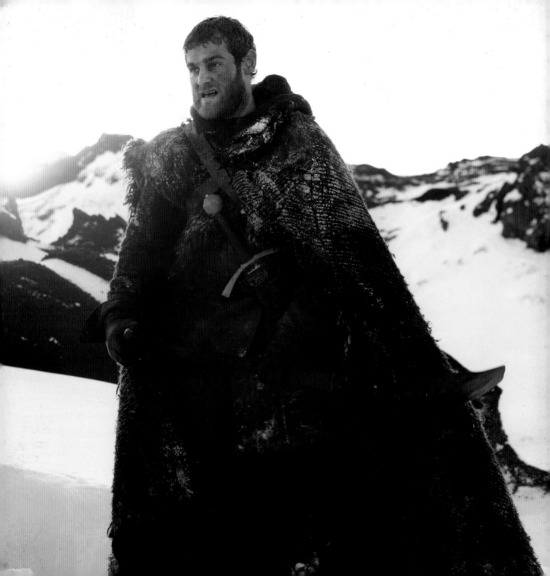

GRENN

NIGHT'S WATCH

"THE GODS AREN'T DOWN HERE. IT'S THE SIX OF US. YOU HEAR ME?"

A strong but slow-witted recruit who joined the Night's Watch at the same time as Jon Snow, he initially resented Jon's arrogance. The two became friends when Jon began teaching swordsmanship to him and Pyp. Grenn died during the Battle of Castle Black, but not before holding the tunnel gate against the wildlings.

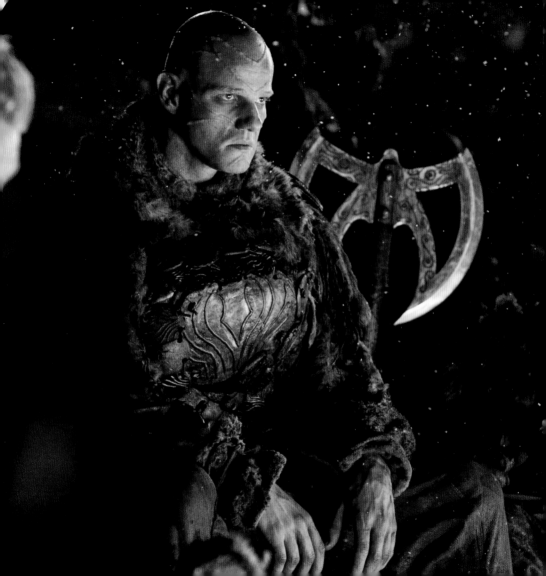

Styr

"Maybe everything is just
better fed down here.
Fat and Lazy. Easier for us."

Leader of the Thenn wildlings, Styr was a fierce warrior
with a hunger for human flesh. He was killed by Jon Snow
during the Battle of Castle Black.

Ygritte

"You know nothing, Jon Snow."

Ygritte was a wildling woman whom Jon Snow encountered on his travels beyond the Wall. Her strong opinions clouded Jon's stance about the Night's Watch, and after Jon infiltrated the wildlings, the two fell in love. He left her to return to Castle Black, only to see her die when the wildlings attacked the fortress.

Beric Dondarrion

Brotherhood Without Banners

"That's what we are: Ghosts.
You can't see us but we see you.
No matter what cloak you wear."

Lord of Blackhaven, Beric Dondarrion arrived in King's Landing
to compete in the Tournament of the Hand, given in honor
of Ned Stark, then Hand of the King. After Gregor Clegane
terrorized the Riverlands, Lord Beric was tasked by Ned to bring
him to justice. A follower of the Red faith, Beric has been brought
back to life several times by Thoros of Myr.

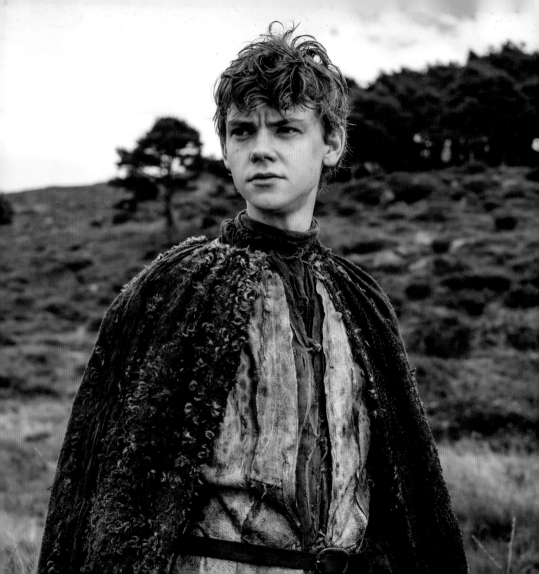

JOJEN REED

HOUSE REED

*"You're a warg, Bran.
It's in your blood."*

The only son of Howland Reed, Lord of Greywater
Watch—who fought alongside Ned Stark during
Robert's Rebellion—Jojen experienced visions similar to
Bran Stark's. Despite the careful protection of his sister
Meera, Jojen was killed in a wight attack while traveling
with Bran, Hodor, and his sister beyond the Wall.

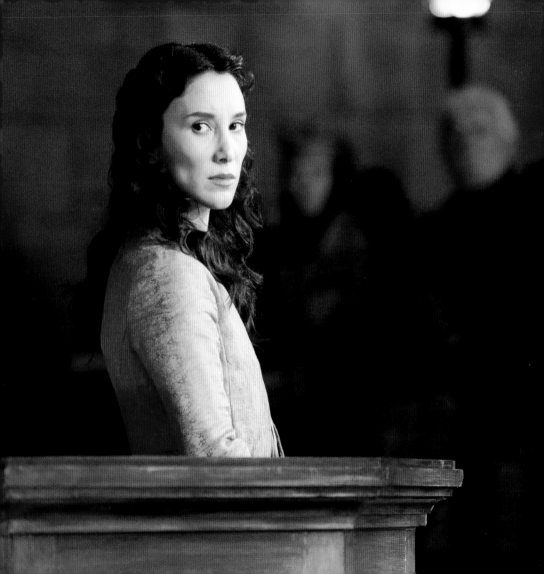

SHAE

"ARE YOU AFRAID, MY LION?"

Shae is a camp follower who made an immediate impression on Tyrion Lannister. Tyrion brought Shae with him to King's Landing but abandoned her, for her own safety, after he married Sansa Stark. Shae denounced Tyrion when he stood trial for the murder of King Joffrey. Tyrion killed her when he found her in his father's bed.

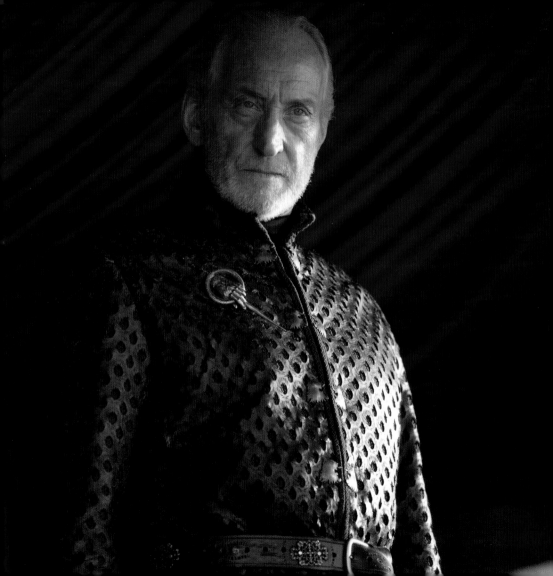

TYWIN LANNISTER

HOUSE LANNISTER

"A LION DOESN'T CONCERN HIMSELF
WITH THE OPINIONS OF A SHEEP."

As Hand to Aerys Targaryen and the richest man in Westeros,
Tywin was believed to be the kingdom's real ruler, an assumption
that angered the Mad King. Tywin returned to King's Landing to
serve as Hand to his grandsons, Joffrey and Tommen, when they
each assumed the throne and once again became the de facto
ruler of the kingdom. He was killed by his son, Tyrion, during
Tyrion's escape from King's Landing.

ALL MEN MUST DIE.